Castles of Wales

Between the Norman invasion in 1066 and the English Civil War in 1651 a succession of armies sought to dominate the landscape and people of Wales by constructing, or in many cases trying to destroy, great stone fortresses. *Castles of Wales* depicts one of the great castle countries of the world. Written by Rhodri Owen. Published by Graffeg.

Contents

GRAFFEG

Introduction

There has never been an era of military construction quite like it. During a 600-year period from the turn of the first millennium, more than 400 castles were built and developed in key strategic locations across Wales.

Whether raised by medieval Welsh princes to defend their homeland from invaders, or constructed by William of Normandy and Edward I to subjugate a proud nation, what remains of these fortresses at the turn of the second millennium amounts to a remarkable legacy. In North Wales alone it is one that has been justly recognised by the United Nations Educational Scientific and Cultural Organisation as a World Heritage Site.

From the splendour of master mason James of St George's *tours de force* at Caernarfon, Beaumaris, Conwy and Harlech, to the spectacular ruins of Carreg Cennen high on a rocky outcrop near Llandeilo; from the oldest stone fortification in Britain at Chepstow, to the comparatively recent Gothic folly of Castell Coch, north of Cardiff, Wales truly is a land of castles.

Many remain remarkably intact; a few are still in regular use today. At others all that remains are a few crumbling towers and battlements. And yet history has left its mark on every parapet and stone wall. In pictures and words this minibook celebrates a selection of Wales's magnificent military landmarks, and the historic figures who built, defended, destroyed or restored them.

Castell Coch

In the 1870s the third Marquess of Bute and architect William Burges branched out from their Victorian Gothic revival of Cardiff Castle to create this fairytale folly on a hillside overlooking the Taff valley just north of the city. Constructed on the ruins of a thirteenth century fort, the 'Red Castle' was lavishly decorated for use as a summer residence. It was completed in 1891, a decade after Burges died and just nine years before the death of the Marquess himself.

Photo: Billy Stock,
© PhotolibraryWales.com.

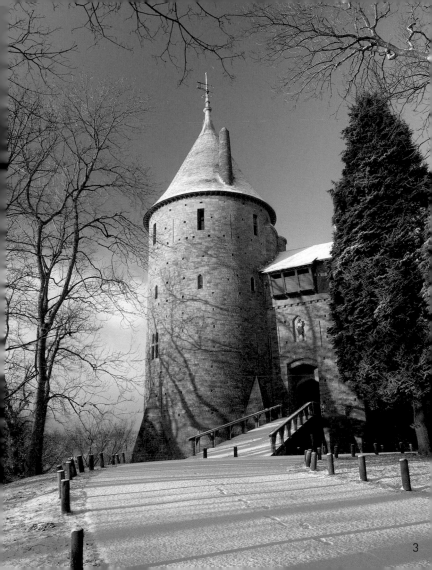

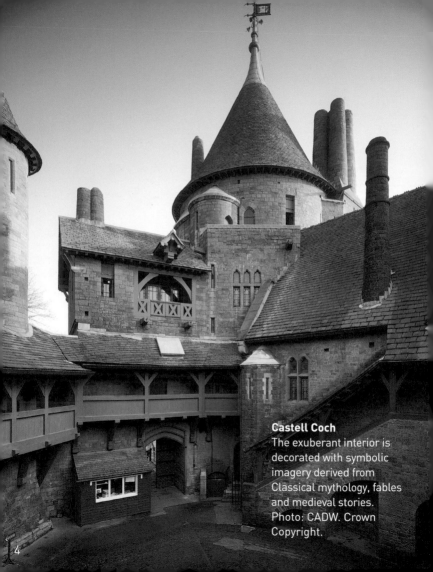

Castell Coch
The exuberant interior is decorated with symbolic imagery derived from Classical mythology, fables and medieval stories.
Photo: CADW. Crown Copyright.

4

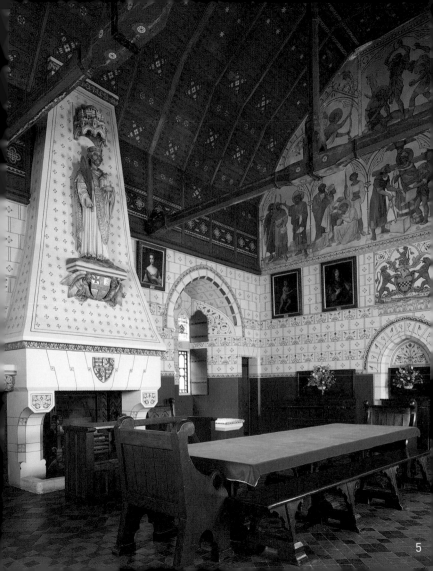

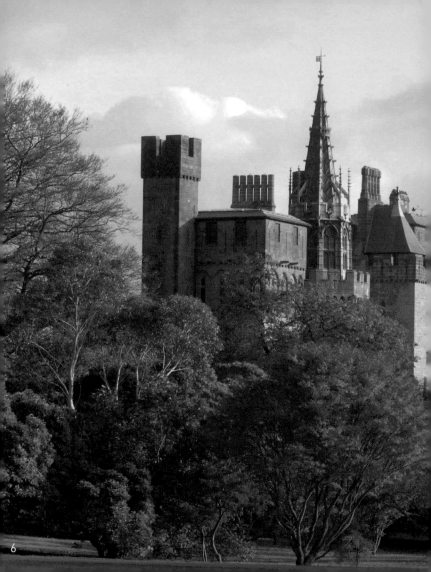

Cardiff Castle
Since its establishment as a Roman fort in 55AD, the Normans, Tudors and, more lately the prosperous Bute family have all left an imprint on this beautifully preserved castle, nestling in the heart of the Welsh capital. In the 1770s 'Capability' Brown developed its grounds and lodgings, while a century later Victorian designer William Burges embarked on a dazzling 16-year Gothic makeover starting with his famous Clock Tower. Owned by the people of Cardiff since 1947.
Photo: Neil Turner,
© PhotolibraryWales.com.

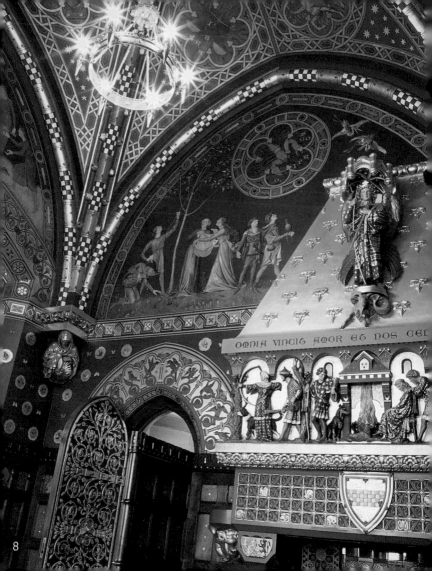

OMNIA VINCIT AMOR ET NOS CED

8

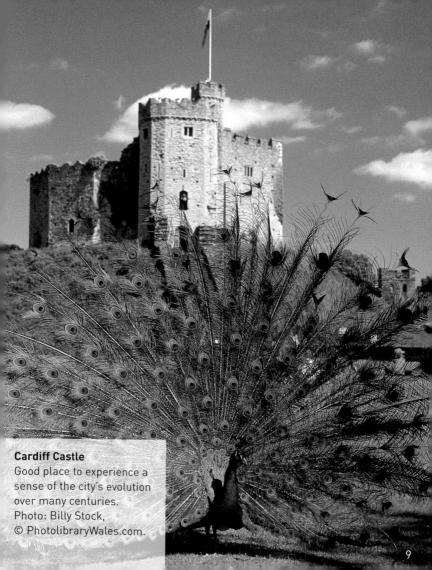

Cardiff Castle
Good place to experience a
sense of the city's evolution
over many centuries.
Photo: Billy Stock,
© PhotolibraryWales.com.

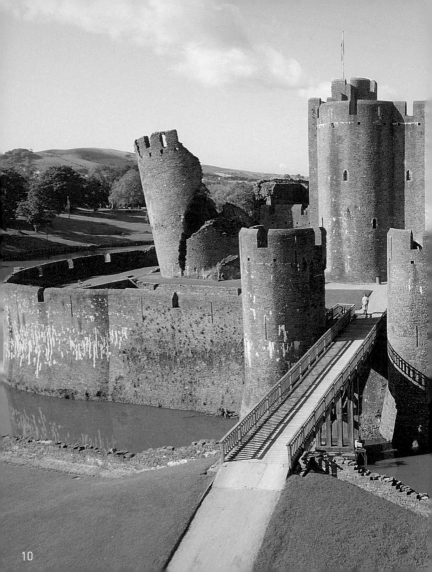

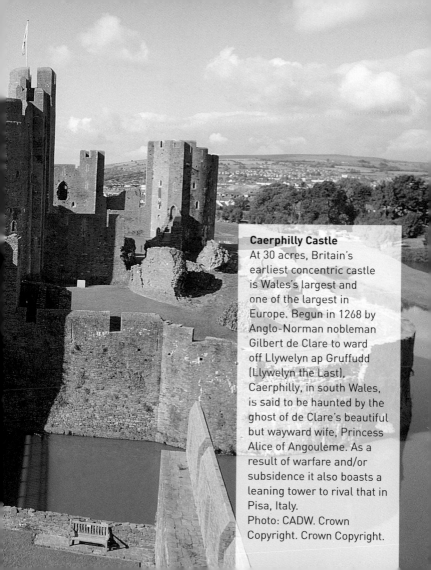

Caerphilly Castle
At 30 acres, Britain's earliest concentric castle is Wales's largest and one of the largest in Europe. Begun in 1268 by Anglo-Norman nobleman Gilbert de Clare to ward off Llywelyn ap Gruffudd (Llywelyn the Last), Caerphilly, in south Wales, is said to be haunted by the ghost of de Clare's beautiful but wayward wife, Princess Alice of Angouleme. As a result of warfare and/or subsidence it also boasts a leaning tower to rival that in Pisa, Italy.
Photo: CADW. Crown Copyright. Crown Copyright.

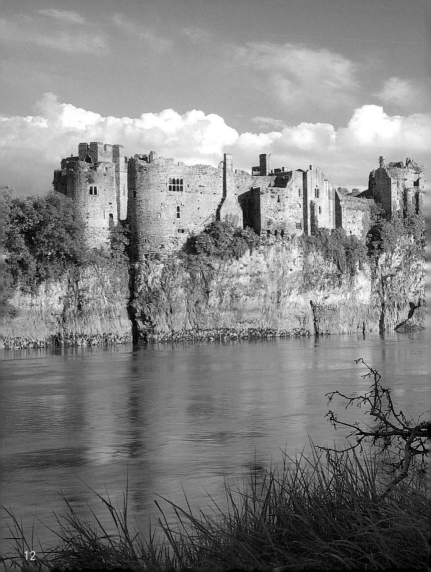

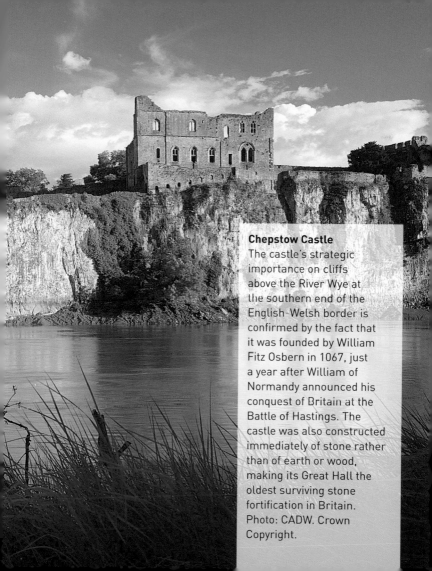

Chepstow Castle

The castle's strategic importance on cliffs above the River Wye at the southern end of the English-Welsh border is confirmed by the fact that it was founded by William Fitz Osbern in 1067, just a year after William of Normandy announced his conquest of Britain at the Battle of Hastings. The castle was also constructed immediately of stone rather than of earth or wood, making its Great Hall the oldest surviving stone fortification in Britain. Photo: CADW. Crown Copyright.

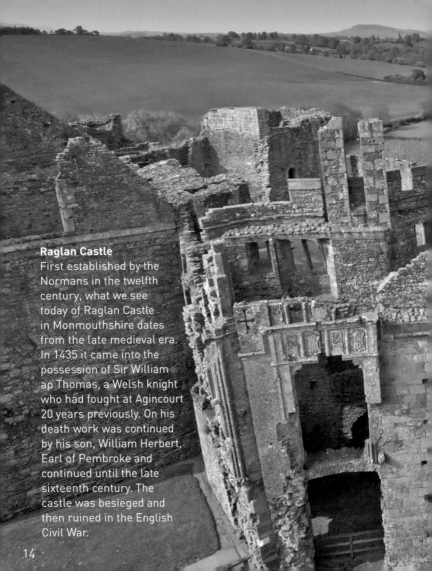

Raglan Castle

First established by the Normans in the twelfth century, what we see today of Raglan Castle in Monmouthshire dates from the late medieval era. In 1435 it came into the possession of Sir William ap Thomas, a Welsh knight who had fought at Agincourt 20 years previously. On his death work was continued by his son, William Herbert, Earl of Pembroke and continued until the late sixteenth century. The castle was besieged and then ruined in the English Civil War.

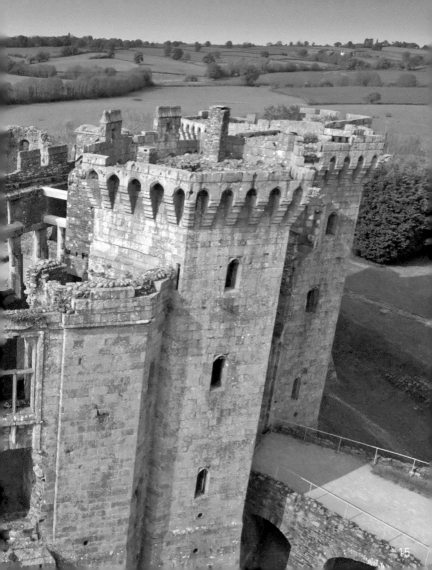

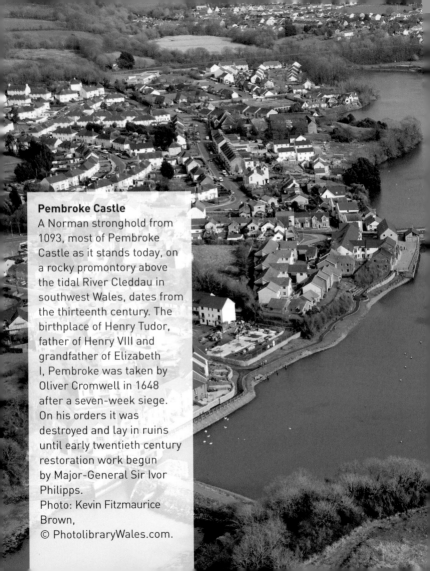

Pembroke Castle
A Norman stronghold from 1093, most of Pembroke Castle as it stands today, on a rocky promontory above the tidal River Cleddau in southwest Wales, dates from the thirteenth century. The birthplace of Henry Tudor, father of Henry VIII and grandfather of Elizabeth I, Pembroke was taken by Oliver Cromwell in 1648 after a seven-week siege. On his orders it was destroyed and lay in ruins until early twentieth century restoration work begun by Major-General Sir Ivor Philipps.
Photo: Kevin Fitzmaurice Brown,
© PhotolibraryWales.com.

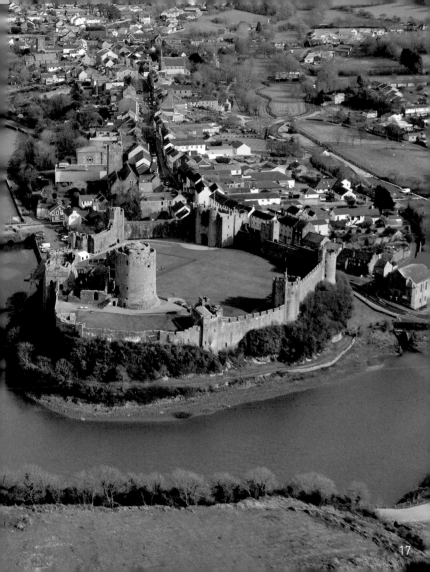

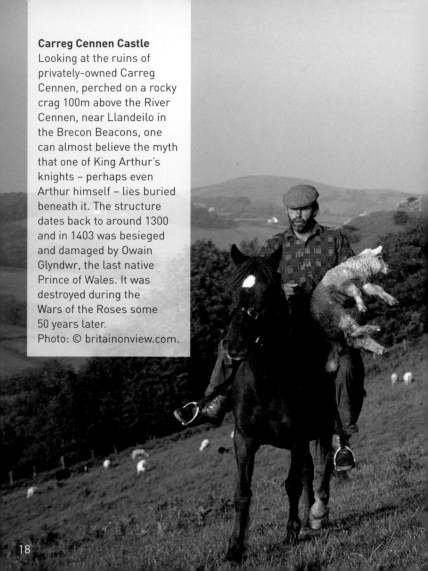

Carreg Cennen Castle
Looking at the ruins of privately-owned Carreg Cennen, perched on a rocky crag 100m above the River Cennen, near Llandeilo in the Brecon Beacons, one can almost believe the myth that one of King Arthur's knights – perhaps even Arthur himself – lies buried beneath it. The structure dates back to around 1300 and in 1403 was besieged and damaged by Owain Glyndwr, the last native Prince of Wales. It was destroyed during the Wars of the Roses some 50 years later.
Photo: © britainonview.com.

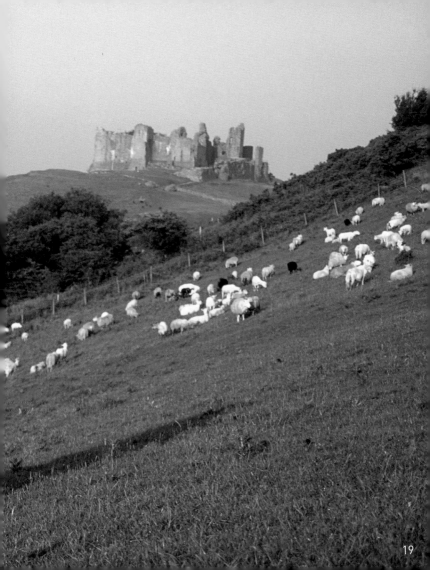

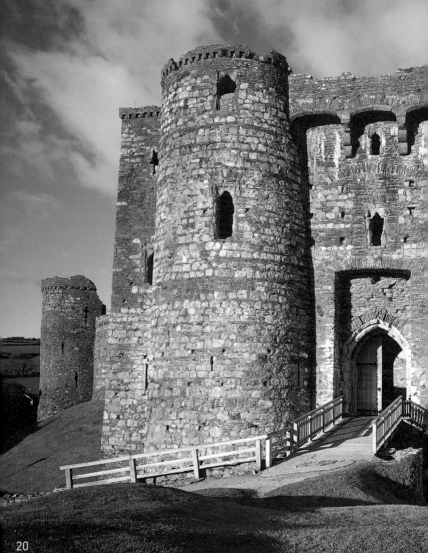

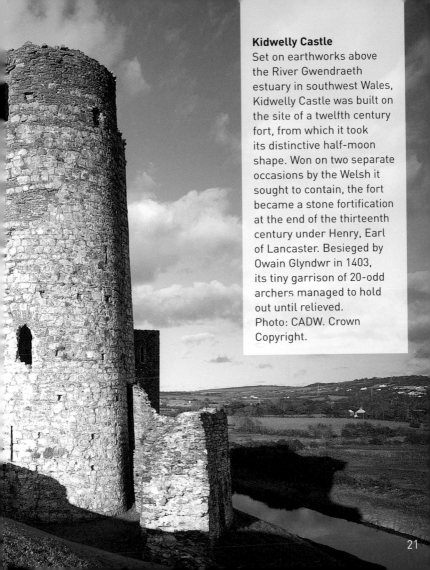

Kidwelly Castle

Set on earthworks above the River Gwendraeth estuary in southwest Wales, Kidwelly Castle was built on the site of a twelfth century fort, from which it took its distinctive half-moon shape. Won on two separate occasions by the Welsh it sought to contain, the fort became a stone fortification at the end of the thirteenth century under Henry, Earl of Lancaster. Besieged by Owain Glyndwr in 1403, its tiny garrison of 20-odd archers managed to hold out until relieved.

Photo: CADW. Crown Copyright.

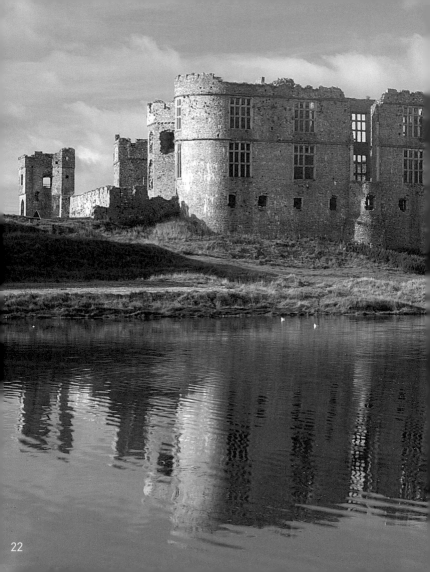

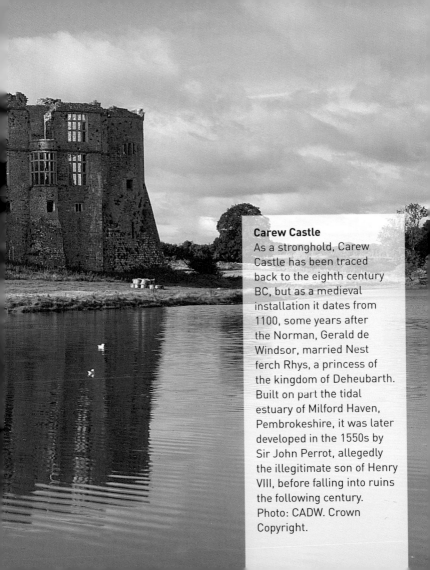

Carew Castle

As a stronghold, Carew Castle has been traced back to the eighth century BC, but as a medieval installation it dates from 1100, some years after the Norman, Gerald de Windsor, married Nest ferch Rhys, a princess of the kingdom of Deheubarth. Built on part the tidal estuary of Milford Haven, Pembrokeshire, it was later developed in the 1550s by Sir John Perrot, allegedly the illegitimate son of Henry VIII, before falling into ruins the following century.
Photo: CADW. Crown Copyright.

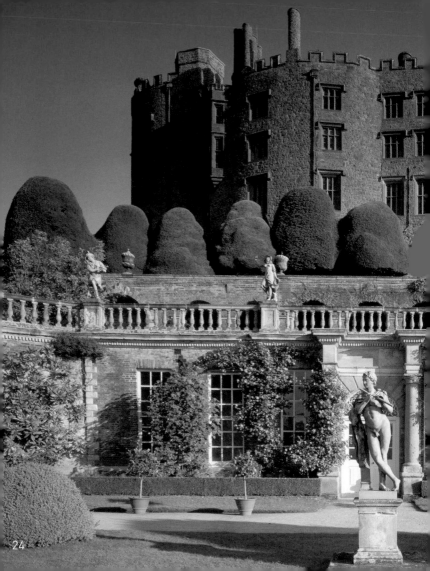

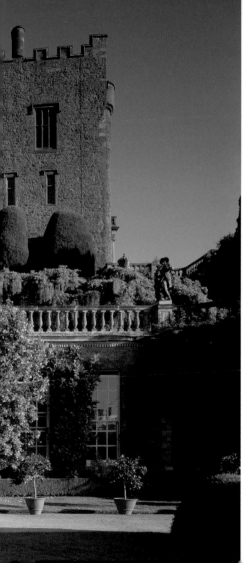

Powis Castle

Unlike most of the castles of Wales, which were intended to suppress the Welsh, Powis was built by the twelfth century princes of Powys to keep out the English. Almost continually inhabited, and today the residence of the eighth Earl of Powis, this distinctive red stone castle still dominates the Severn Valley just south of Welshpool, Powys. Among its attractions are a beautiful seventeenth century Italianate garden and The Clive Museum, home to many treasures from India.
Photo: britainonview / NTPL / Andrew Butler.

Harlech Castle

A concentric castle noted for its large gatehouse, Harlech, begun in 1283, was the setting for the longest siege in British history. During the Wars of the Roses, the Lancastrians under Dafydd ap Ieuan held out for seven years from 1461-1468, a feat commemorated by the song 'Men of Harlech'. Half a century earlier Harlech Castle had been the site of Owain Glyndwr's second parliament and was successfully besieged in 1409 by Prince Henry – later Henry V.

Photo: Steve Lewis,
© PhotolibraryWales.com.

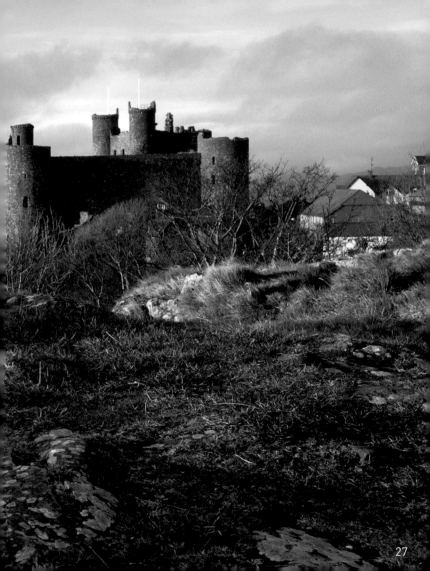

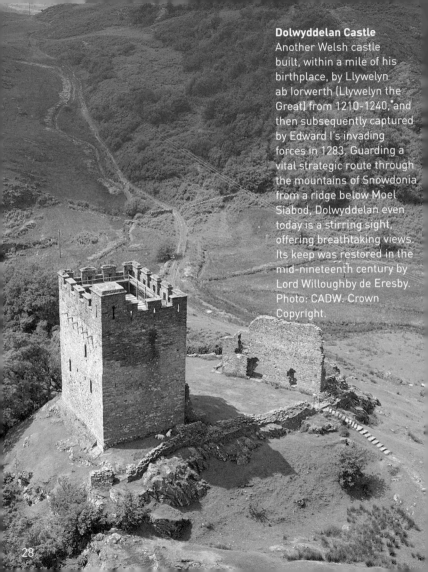

Dolwyddelan Castle
Another Welsh castle built, within a mile of his birthplace, by Llywelyn ab Iorwerth (Llywelyn the Great) from 1210-1240, and then subsequently captured by Edward I's invading forces in 1283. Guarding a vital strategic route through the mountains of Snowdonia from a ridge below Moel Siabod, Dolwyddelan even today is a stirring sight, offering breathtaking views. Its keep was restored in the mid-nineteenth century by Lord Willoughby de Eresby. Photo: CADW. Crown Copyright.

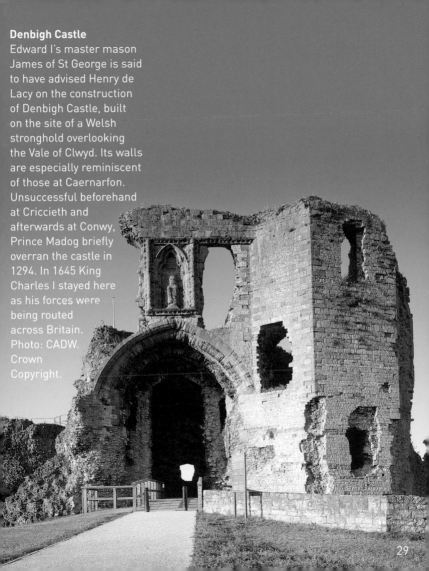

Denbigh Castle

Edward I's master mason James of St George is said to have advised Henry de Lacy on the construction of Denbigh Castle, built on the site of a Welsh stronghold overlooking the Vale of Clwyd. Its walls are especially reminiscent of those at Caernarfon. Unsuccessful beforehand at Criccieth and afterwards at Conwy, Prince Madog briefly overran the castle in 1294. In 1645 King Charles I stayed here as his forces were being routed across Britain. Photo: CADW. Crown Copyright.

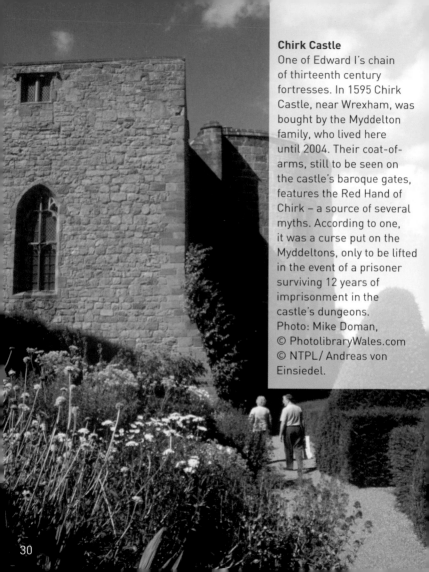

Chirk Castle

One of Edward I's chain of thirteenth century fortresses. In 1595 Chirk Castle, near Wrexham, was bought by the Myddelton family, who lived here until 2004. Their coat-of-arms, still to be seen on the castle's baroque gates, features the Red Hand of Chirk – a source of several myths. According to one, it was a curse put on the Myddeltons, only to be lifted in the event of a prisoner surviving 12 years of imprisonment in the castle's dungeons.

Photo: Mike Doman,
© PhotolibraryWales.com
© NTPL/ Andreas von Einsiedel.

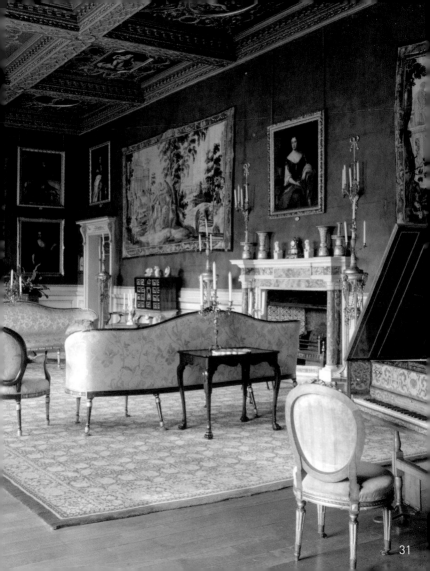

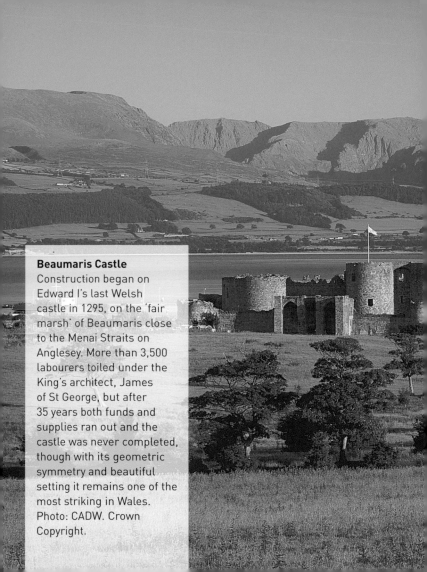

Beaumaris Castle
Construction began on Edward I's last Welsh castle in 1295, on the 'fair marsh' of Beaumaris close to the Menai Straits on Anglesey. More than 3,500 labourers toiled under the King's architect, James of St George, but after 35 years both funds and supplies ran out and the castle was never completed, though with its geometric symmetry and beautiful setting it remains one of the most striking in Wales.
Photo: CADW. Crown Copyright.

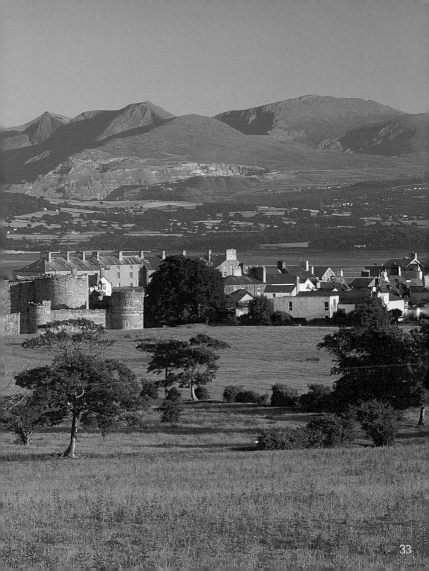

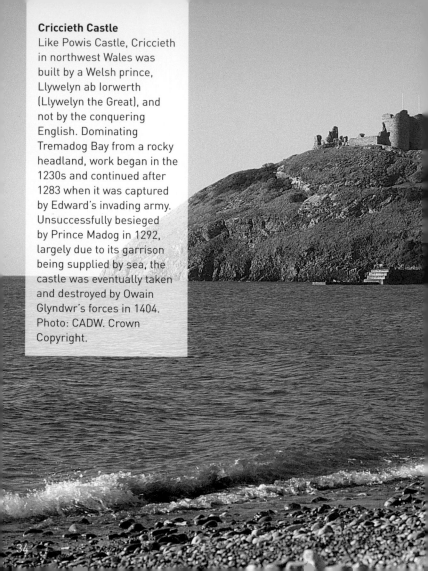

Criccieth Castle
Like Powis Castle, Criccieth in northwest Wales was built by a Welsh prince, Llywelyn ab Iorwerth (Llywelyn the Great), and not by the conquering English. Dominating Tremadog Bay from a rocky headland, work began in the 1230s and continued after 1283 when it was captured by Edward's invading army. Unsuccessfully besieged by Prince Madog in 1292, largely due to its garrison being supplied by sea, the castle was eventually taken and destroyed by Owain Glyndwr's forces in 1404. Photo: CADW. Crown Copyright.

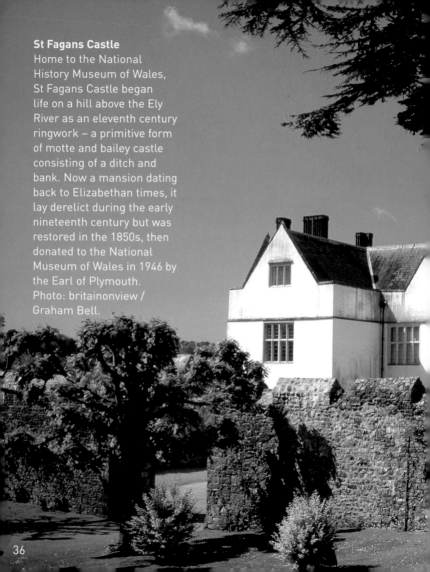

St Fagans Castle
Home to the National
History Museum of Wales,
St Fagans Castle began
life on a hill above the Ely
River as an eleventh century
ringwork – a primitive form
of motte and bailey castle
consisting of a ditch and
bank. Now a mansion dating
back to Elizabethan times, it
lay derelict during the early
nineteenth century but was
restored in the 1850s, then
donated to the National
Museum of Wales in 1946 by
the Earl of Plymouth.
Photo: britainonview /
Graham Bell.

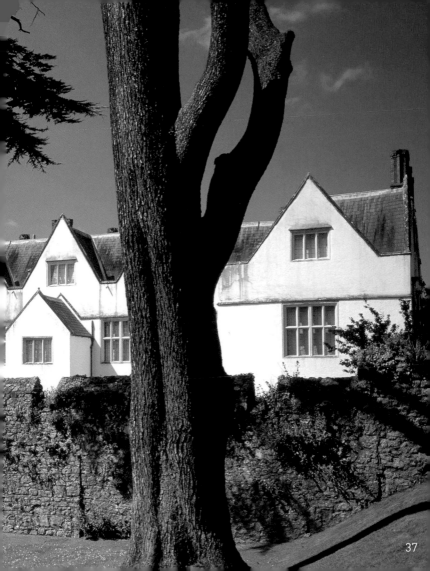

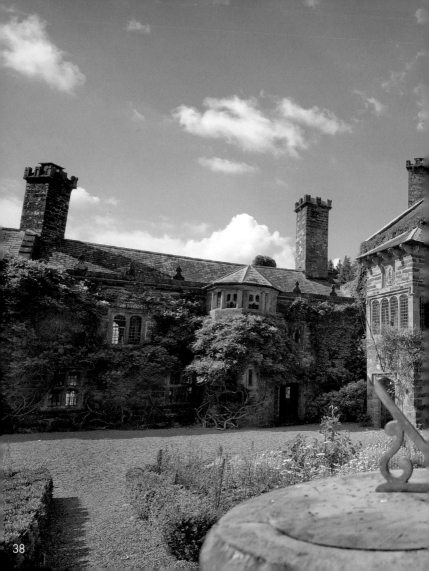

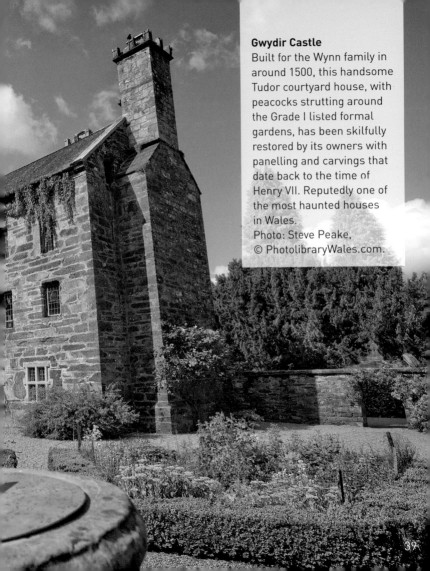

Gwydir Castle

Built for the Wynn family in around 1500, this handsome Tudor courtyard house, with peacocks strutting around the Grade I listed formal gardens, has been skilfully restored by its owners with panelling and carvings that date back to the time of Henry VII. Reputedly one of the most haunted houses in Wales.
Photo: Steve Peake,
© PhotolibraryWales.com.

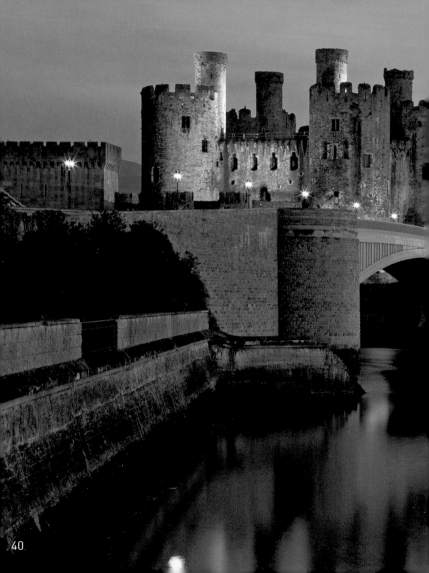

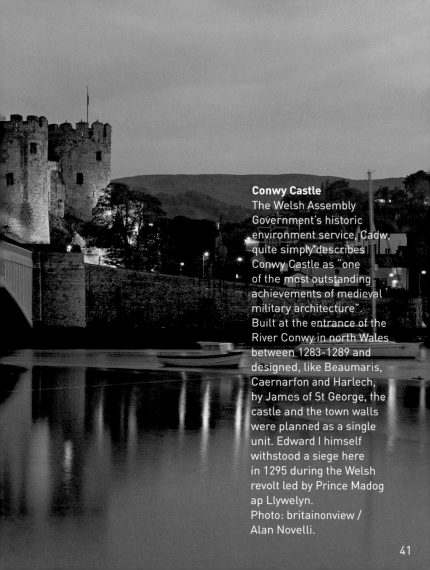

Conwy Castle
The Welsh Assembly Government's historic environment service, Cadw, quite simply describes Conwy Castle as "one of the most outstanding achievements of medieval military architecture". Built at the entrance of the River Conwy in north Wales between 1283-1289 and designed, like Beaumaris, Caernarfon and Harlech, by James of St George, the castle and the town walls were planned as a single unit. Edward I himself withstood a siege here in 1295 during the Welsh revolt led by Prince Madog ap Llywelyn.
Photo: britainonview / Alan Novelli.

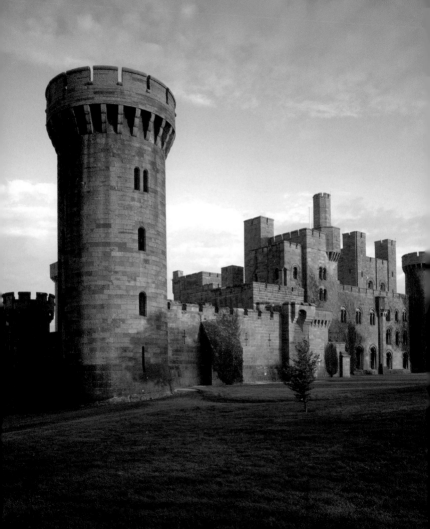

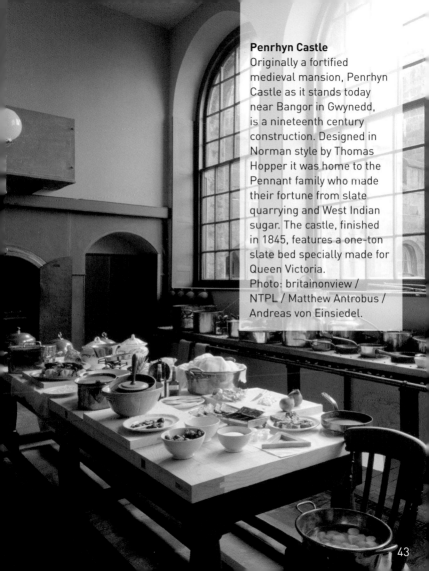

Penrhyn Castle
Originally a fortified medieval mansion, Penrhyn Castle as it stands today near Bangor in Gwynedd, is a nineteenth century construction. Designed in Norman style by Thomas Hopper it was home to the Pennant family who made their fortune from slate quarrying and West Indian sugar. The castle, finished in 1845, features a one-ton slate bed specially made for Queen Victoria.
Photo: britainonview / NTPL / Matthew Antrobus / Andreas von Einsiedel.

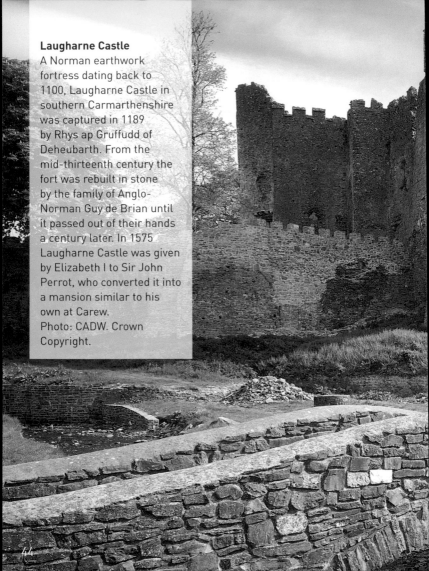

Laugharne Castle

A Norman earthwork fortress dating back to 1100, Laugharne Castle in southern Carmarthenshire was captured in 1189 by Rhys ap Gruffudd of Deheubarth. From the mid-thirteenth century the fort was rebuilt in stone by the family of Anglo-Norman Guy de Brian until it passed out of their hands a century later. In 1575 Laugharne Castle was given by Elizabeth I to Sir John Perrot, who converted it into a mansion similar to his own at Carew.
Photo: CADW. Crown Copyright.

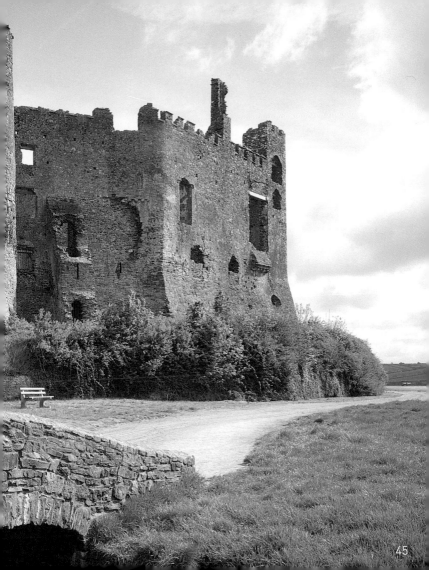

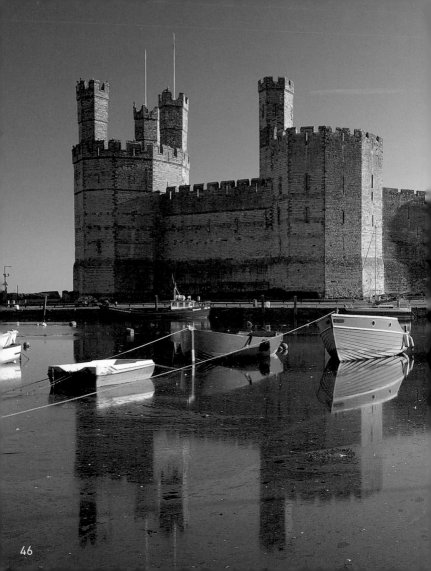

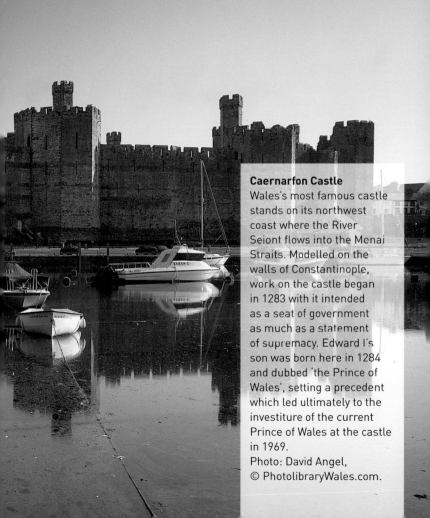

Caernarfon Castle

Wales's most famous castle stands on its northwest coast where the River Seiont flows into the Menai Straits. Modelled on the walls of Constantinople, work on the castle began in 1283 with it intended as a seat of government as much as a statement of supremacy. Edward I's son was born here in 1284 and dubbed 'the Prince of Wales', setting a precedent which led ultimately to the investiture of the current Prince of Wales at the castle in 1969.

Photo: David Angel,
© PhotolibraryWales.com.

Cover: Conwy Castle,
Photo: Pierino Algieri.
© PhotolibraryWales.com.

Useful websites

www.visitwales.co.uk
www.ccw.gov.uk (National Trails)
www.snowdonia-npa.gov.uk
(Snowdonia National Park)
www.pembrokeshirecoast.org
(Pembrokeshire National Park)
www.visitbreconbeacons.org
(Brecon Beacons National Park)
www.photolibrarywales.co.uk
www.tourwales.org.uk
www.cadw.wales.gov.uk
www.nationaltrust.org.uk
www.graffeg.com

Published by Graffeg
First published 2008
© Graffeg 2008
ISBN 9781905582266

Graffeg, Radnor Court,
256 Cowbridge Road East,
Cardiff CF5 1GZ Wales UK.
www.graffeg.com
are hereby identified as the authors
of this work in accordance with
section 77 of the Copyrights,
Designs and Patents Act 1988.

A CIP Catalogue record for this book
is available from the British Library.

Designed and produced by
Peter Gill & Associates
www.petergill.com